J.S.G. BOGGS
smart money
(HARD CURRENCY)

An exhibition organized by The Tampa Museum of Art

Sponsored by SunBank of Tampa Bay

EXHIBITION SCHEDULE

TAMPA MUSEUM OF ART
Tampa, Florida

CARNEGIE MELLON UNIVERSITY ART GALLERY
Pittsburgh, Pennsylvania

SMITH COLLEGE MUSEUM OF ART
Northhampton, Massachusetts

GRAND RAPIDS ART MUSEUM
Grand Rapids, Michigan

LARAMIE COUNTY COMMUNITY COLLEGE
Cheyenne, Wyoming

26441

Front Cover: SEROUS (ONE HUNDRED DOLLAR BILL - # B 05071989 B)
 1989
 Acrylic on canvas
 63 x 147 In.

Back Cover: FOUNDATIONS OF AMERICAN VALUES
 1990
 Acrylic on canvas
 67 x 147 In.

Editor: Ann S. Olson
Chief designer: Robert Hellier
Cover design: R. Andrew Maass
Catalogue design: Carolyn K. Connerat, Marlene D. Boggs
Printed by: Tampa Printing Company
Photography: Front Cover: Mark Sink
 Inside pages and Back Cover: Bill Orcutt
Holographic portrait in Framed, p. 19: Anna Marie Nicholson, Museum of Holography, New York City

Originally, this catalog was designed to present all images of United States currency at their actual dimensions and in full color. The blank space on this page represents the Museum's attempt to publish the catalogue prior to the intervention of the U. S. Secret Service. Following notice given to them by an employee of the printer, the Secret Service advised the printer that all the color images were "in violation" of U.S. Statutory Code 18, Section numbers 474 and 504. All printing was halted and the color proofs were taken by the Secret Service and sent to Washington, D. C. for inspection by the Treasury Department. No further formal word has been heard.

The works represented in this catalogue illustrate the artwork of J.S.G. Boggs done in acrylic and/or ink at sizes vastly larger than actual currency. It is not the intent of the artist or of this Museum to engage in counterfeiting or forgery. This catalogue has been printed to permanently document the work of a fine artist. In order to comply with the proper statuatory code and sections, the images printed here are 150% larger than actual U.S. currency.

CONTENTS

FOREWORD

Five years ago, I began receiving insistent telephone calls from what sounded like a brash, single-named artist of unfamiliar talent. Throwing about a list of young up-and-coming New York artists and one or two local ones, this "Boggs" insisted upon an appointment. After a reference from an artist friend, I relented and scheduled an appointment, making sure that my secretary had an escape route at hand just in case.

As the appointed hour approached, a tall, thin, long-haired and caped young artist appeared in the outer office—early. Once past the obligatory "Who do you knows?" we reached a common ground upon which we both could converse. Sure enough, he really was just Boggs. His three initials did have names to go with them—James Stephen George. His parents live in the Tampa area and he had attended Hillsborough Community College, where he studied under the artist Stephen Holm. Since then, his career has been peripatetic: he bounced from Tampa to New York City to London and back.

During our first meeting, and beyond the flash, a seriousness of purpose, a concern and appreciation for his roots, his mentors, and a keen intellect attuned to historical antecedents became more and more apparent. What I thought might be a flaky, courtesy conversation turned into an absorbing, challenging discussion about Tampa, its art scene, the Museum and his own developing and maturing art. It became the first of many such conversations.

What I discovered in Boggs, and continue to discover, is a passion for art and artistry, as well as a seriousness softened by playfulness that borders on bluster with a dash of Barnumesque showmanship. Boggs is a challenge to our concept of art's value in a monetary sense and the value of money itself. Early on, Boggs painted numbers, individually and in sequence, much as Robert Indiana did with letters and words. But whether painted numbers or words, these works were often bought by people who not only saw a value in the visual quality of the art, but also placed a monetary value on the works by purchasing them for "dollars." Moving from trompe l'oeil numbers to painting and drawing actual paper currency became a natural step.

Perhaps even more natural was Boggs's stepping from the mere depiction of currency to the use of "his" money in place of the the legitimate currency issued by governmental entities. Boggs's "bartering" could, and often did, combine the use of "real" money along with his own. Even I participated in Boggs's process art. In 1987, I purchased a United States Government one-dollar bill from Boggs for ten dollars. A sucker born every minute, you say? One who values the "process" in making art, say I! Through the purchase of one hundred new one-dollar bills in sequence and then documenting directly on them his name, the date, the project title, his gallery affiliation and finally affixing his signature, Boggs intended to transform this single bill into a work of art, a part of a larger project. I have yet to see the complete project, but I think it worth the ten spot to see how it shakes out.

Others, more traditionally and legally bound, have not been as accepting of Boggs's bartering or drafting skills. Twice arrested for and twice acquitted of counterfeiting, Boggs has joined the ranks of a long list of respected money painters whose skills challenge the eye as well as the law. It is Boggs who has updated the challenge and turned a new twist. Seeing is believing.

Three years ago, I committed the Museum to this exhibition. Its composition has changed, but not its premise. Money, like art, is a symbol—a symbol that has value. Without the appreciation of both, this exhibition would not be possible. On behalf of the Museum, I wish to thank SunBank for its active participation and generous support. SunBank is a believer in reality, and Boggs's work helps to interpret a part of that reality. Others, too, were intricately involved and deserve to be acknowledged: Carolyn K. Connerat, who helped organize the work, the venues, this catalogue and Boggs; Bruce W. Chambers and Arthur C. Danto, who have written superb essays putting Boggs in his proper place among money painters; Vrej Baghoomian, who gave the initial moral support; Ann S. Olson and Marlene D. Boggs for the editing and composition of this work; and Boggs, whose name may become a part of the future lexicon of art exchange—as in a "Boggsian" transaction.

R. Andrew Maass
Director

LENDERS TO THE EXHIBITION

Mr. and Mrs. Maurice A. Amon

Vrej Baghoomian Gallery

James H. Boggs

Carolyn K. Connerat

HansRudi Demenga

David Dugan

Mr. and Mrs. Gerald S. Fineberg

Bill Gavin

Stephen E. Holm

Caroline Rose Hunt

Dr. Robert E. Kahn

David Randall King

Phyllis and William L. Mack

Jerry Yeprem Nazarian

Rosewood Hotel Corporation

Private Collections

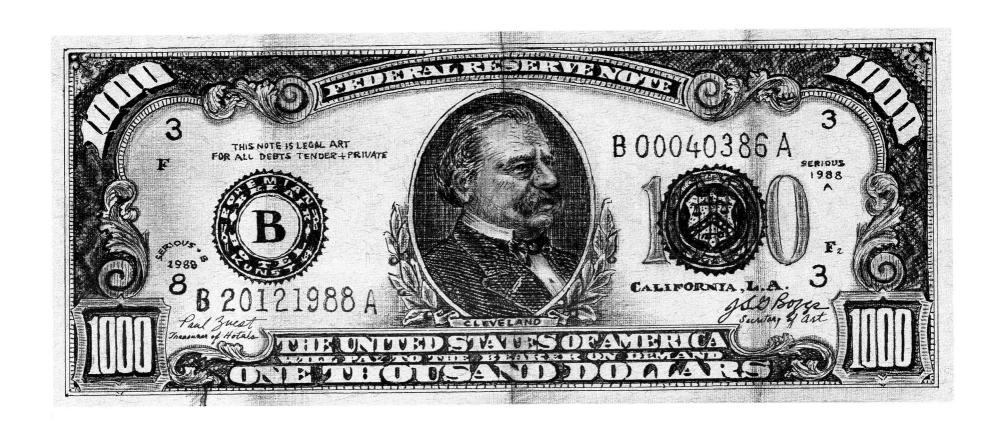

One $1,000 U.S. Bill # B 20121988 A
1988, Ink and colored pencil on Strathmore bond, 2 5/8 x 6 1/8 In.

J.S.G. BOGGS—THE DIMENSIONS OF MONEY

BRUCE W. CHAMBERS

" We tried to get rid of trompe l'oeil to find a trompe l'esprit."
— Pablo Picasso[1]

My first encounter with Boggs began with a phone call in the Spring of 1988. "This is Boggs," he informed me, brimming with self-confidence. "I hear you are doing an exhibition on money painting. I'd like to come over and talk to you about it."

At the time, I was working at the old Berry-Hill Galleries on Fifth Avenue, and was in the midst of preparing for the exhibition Boggs referred to. For the first time, I was going to bring together in one place the works of the late nineteenth-century American trompe l'oeil still-life painters who had specialized in images of paper currency. Calling the exhibition, somewhat cheekily, "Old Money," Berry-Hill had planned for it to coincide with the opening of its new gallery space on East 70th Street the following November.[2]

As it turned out, Boggs had been referred to me by my friend, Ed Nygren, then Chief Curator at the Corcoran Gallery of Art in Washington and now Director of the Smith College Museum of Art, and a fellow scholar of trompe l'oeil painting. I knew that Ed was working on his own article on money painting and had talked with him frequently about what might have driven this small group of American artists to their strange, almost obsessive, interest in paper currency.[3]

I had also heard of Boggs, primarily on account of the now-famous articles on his arrest and trial for counterfeiting that Lawrence Weschler had written for *The New Yorker* that January.[4] At the end of the eighties, it seemed like there was once again in America a real fascination, not only with money generally, but also with art whose subject was money.

Since this paralleled, by exactly a century's remove, the nearly identical preoccupation which I was chronicling in the "Old Money" exhibition, I welcomed Boggs's visit. I was as interested in what he had to say about making art out of money today as he was in whatever I might contribute to his understanding of the money painters of the past.

In the many conversations I have had with Boggs since that first phone call, I have come to realize the depth of his passion for making art which is also, in some sense or other, money. While his creative mission has many facets, one of the most important is the obligation he feels to the artists he now identifies as his ancestors: William Michael Harnett, John Haberle, John F. Peto, Nicholas A. Brooks and Victor Dubreuil—the artists who formed the core of the "Old Money" exhibition.

Boggs was already drawing his own money and exchanging it for various goods and services around the world before he discovered that there had been others before him whose steps he seemed to be mirroring. The discovery came as a revelation, and provided Boggs, in his own work, with an unforeseen dimension of mystery and intrigue.

First of all, there was the question of whether drawing or painting exact replicas of paper currency constituted counterfeiting. It seemed to Boggs and his defenders in his counterfeiting trials in England and, later, Australia, that the question hinged not only on the verisimilitude of the work but also on the author's intent. In every transaction Boggs completed, he openly described his hand-drawn bills as works of art, signed them as his personal artistic creations, and exchanged them as such, however much they may have resembled "real money." If Boggs's drawings—however accurately they replicated legal currency—were created and promoted as works of art, and not as money, then they could hardly be seen as perpetrating a deliberate fraud.

It was on that very same point that Harnett and other late-nineteenth century trompe l'oeil money painters accused of or even arrested for counterfeiting were finally cleared as well. A painting in oil on canvas or wood of a ten-dollar bill, sometimes accompanied by other illusionistically-drawn objects and usually signed by the artist, could not easily be mistaken for the real thing.

But the question still lingered in the minds of the authorities responsible for bringing counterfeiters to justice that, if an artist was good enough to paint such convincing images of money, could he not also, just as easily, have produced true counterfeits and passed them off on an unsuspecting public? Beginning in the mid-1880s, the Secret Service launched campaigns against most of the money painters, eventually persuading many—but not all—to desist from labors that, however innocent, might be misconstrued. As Boggs has noted elsewhere, there were eerie parallels, even to the date of the arrest of Harnett, between the prosecutions of the nineteenth-century money painters and the Bank of England's insistence on Boggs's own arrest and trial on charges of counterfeiting.[5]

But few of the nineteenth-century artists worked on paper, Boggs's initial medium in his transactions—and the medium of currency itself. There was another revelation waiting for Boggs when he arrived at Berry-Hill Galleries: the

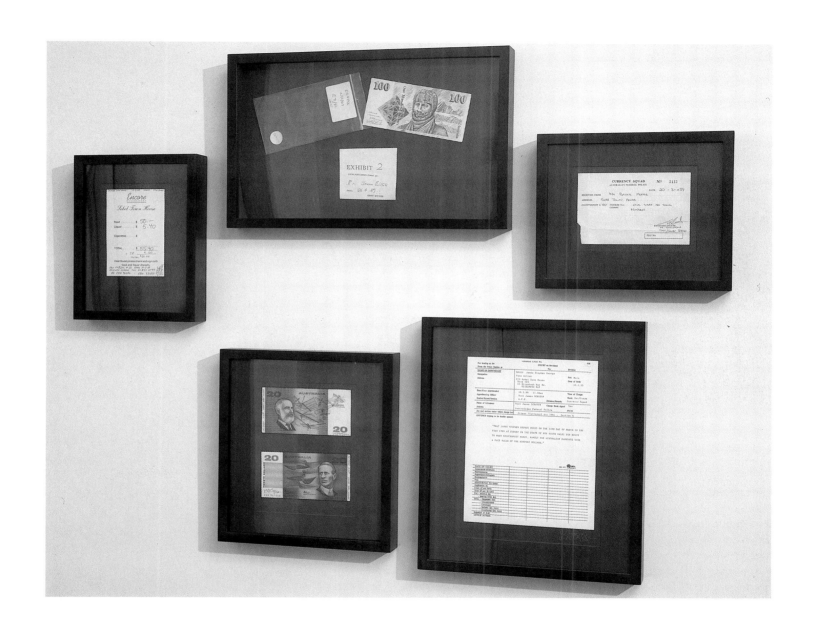

ENCORE (DINNER WITH ANN) - 1989, Mixed media, 35 x 45 In.

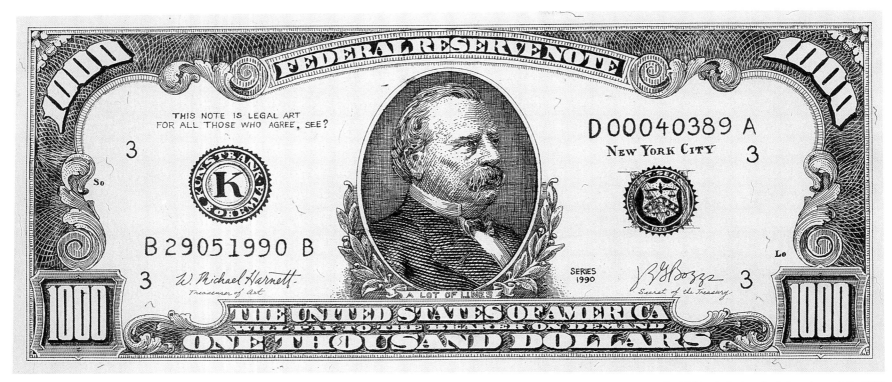

THIS NOTE IS LEGAL ART
FOR ALL THOSE WHO AGREE, SEE?

D 00040389 A
NEW YORK CITY

B 29051990 B

W. Michael Harnett.
Treasurer of Art

A LOT OF LINES

SERIES
1990

Secret. of the Treasury.

FEDERAL RESERVE NOTE

THE UNITED STATES OF AMERICA
WILL PAY TO THE BEARER ON DEMAND
ONE THOUSAND DOLLARS

K NOTE # B 29051990 B - 1990, Ink and colored pencil on Basingwerk paper, 4 1/2 x 10 3/8 In.

work of Otis Kaye, a Chicago engineer who pursued trompe l'oeil money painting as a hobby between 1917 and the early 1950s. Kaye, whose works have only recently been rediscovered, knew and made reference to the work of his own predecessors long before they had been studied or even recognized by the art world. His art thus serves as a direct link between the paintings of the late 1880s and 1890s and more recent money images, not only by Boggs, but also by Andy Warhol, Barton Benes and others.

What makes Kaye special for Boggs is that towards the end of his career in the early 1950s, Kaye made a series of carefully hand-drawn bills in colored inks on paper—exactly as Boggs was doing some thirty-five years later. Like Boggs's work, these are one-sided drawings, signed and dated by the artist, and they were good enough to have circulated as counterfeits had they been glued together and the signature erased. Kaye carefully concealed all of these bills, even from his family, probably because they were prosecutable as counterfeits in the fifties. It was only when Kaye

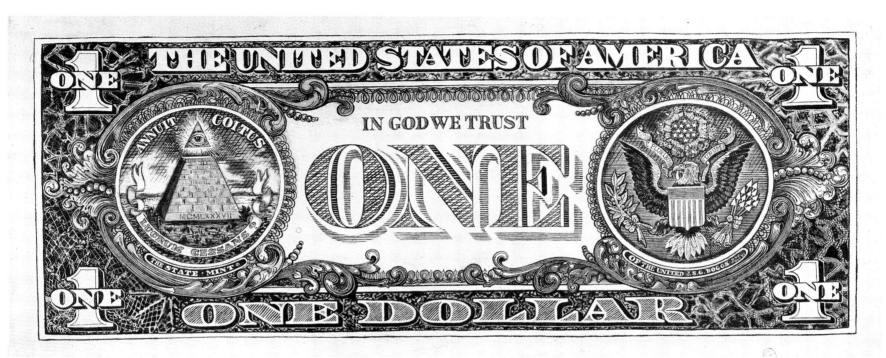

paintings began to command substantial prices in the eighties that one of his descendants uncovered the hidden trove of paper bills in a box of old Christmas ornaments.

On Boggs's first visit to the gallery, I showed him some of Kaye's drawings. One of these, a beautifully rendered image of the reverse side of a ten-dollar bill, particularly excited Boggs. He asked if it could be held for him for later purchase, explaining that, immediately after his jury acquittal in the Old Bailey the previous November, he had sworn to live solely by his art transactions for a full year. Would I be kind enough, then, to set this one drawing aside for him until November 24th, the day after the anniversary of his acquittal?

It so happened that Boggs's proposed date fell right in the middle of our "Old Money" exhibition, and it was likely that, if the drawing were not held for Boggs, it would quickly be sold to someone else. Since Boggs had no visible means of support at the time, and no prospects of making any money besides his own, a promise to hold the drawing for him

clearly presented an element of risk. Jim and Fred Hill, the owners of Berry-Hill Galleries, nonetheless reluctantly agreed. They did so in part because of Boggs's genuine enthusiam for the work and also because his long, often arduous experience trying to persuade strangers to accept his money in exchange for food, accomodations and other rewards, had made Boggs an extremely adept salesman.

The exhibition opened, and Boggs attended, fresh from another trip abroad (which included his arrest for counterfeiting in Australia). He reiterated his promise to acquire the drawing on the appointed date. While for various reasons the specific date was missed, Boggs did get the drawing—but he did not purchase it in any sense of the word.

Instead, as is his preference, he came to us with a proposal to acquire the drawing in exchange for bills of his own making. Besides the sale itself, the only thing he required of us was that we draw up a legally binding contract, a bill of sale, showing that we had accepted his money in payment for Kaye's. It was impossible not to feel that we were trading one kind of funny money for another, exchanging works of art that had somehow been transformed before our very eyes into promissory notes. But we did so consciously; we were not tricked into compliance. It was all very carefully explained and, perhaps even more cautiously, agreed to. And it took place exactly as we had agreed.

In many ways, Boggs is a throwback to the old Protestant ethic: "A man's word is as good as his bond." He asks us to look at monetary transactions, not as we have become accustomed to doing, as a matter of blind habit, but afresh. The original nineteenth-century resistance to "fiat currency"—the "Greenbacks" that could not be redeemed in cold, hard coin, but only in replicas of themselves, and then only on the government's say so—was that it was all too much *an act of faith,* a paper promise from which any Treasury official or banker could walk away with impunity if he or she took the fancy.

By asking us to reexamine the meaning of money, Boggs restores to money the element of trust. I can accept that piece of paper from you in lieu of "hard cash" *because* I trust that you (or someone who you have authorized to represent you) will keep the promise that it symbolizes.

But of course, this is all terribly old-fashioned. In an era of credit and debit cards, teller machines and electronic transfers of vast sums, surely no one thinks about money this way anymore, as a tangible contract between individuals. Perhaps they should. It is, after all, also the era of the savings and loan bailout, of insider trading and junk bond takeovers, and of easy bankruptcy, used as a lever not merely to refinance debt but also to evade commitments to labor contracts, legal claims and pension funds.

Similar issues drove the money painters of a century ago, when debate over the meaning of money was, if anything, more heated than it is today. After the Civil War the country was divided about equally between the supporters of one or another kind of money. There were those, primarily representing the large banking and industrial interests of the Northeast, who insisted that all money be backed by gold, and that no money be issued that was not redeemable in gold on demand. Others, like the farmers of the South and Midwest, where gold reserves were less likely to have been assessed in quantity, saw the money supply in their regions dry up regularly in painful deflationary cycles, and pleaded with Congress to create forms of money that could loosen the wheels of commerce—if not the "Greenbacks" mentioned

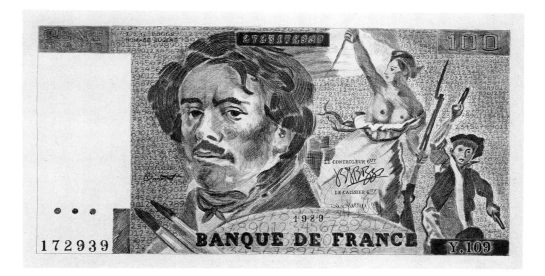

CENT FRANC
1989
Pencil on paper
16 1/2 x 30 1/4 In.

earlier, then at least money backed by silver, which was more plentiful than gold. In his most famous speech, the great orator and Democratic Presidential candidate, Williams Jennings Bryan, spoke for all those who felt disenfranchised by the "hard money" policies of the day: "You shall not crucify mankind upon a cross of gold!"[6]

By the kind of money they chose to depict, by their wry inclusions of other objects in their illusionistic paintings, and by their verbal as well as visual puns and other forms of internal commentary, the older money painters joined in these debates, taking one or the other side. Boggs also alters his currency, exercising considerable license with the various mottoes, titles and other words that necessarily appear on currency. Each bill is personalized with Boggs's own messages, but at the same time many of those altered messages appear to carry larger meanings.

Money painting has always been a moralizing art. Its roots are in Renaissance painting, particularly of the Netherlands, and specifically in the often-satirical portraits of usurers and misers. Among the direct descendants of the piles of coins that appear in these allegories of avarice are Victor Dubreuil's images of overflowing barrels of money, painted in the 1890s, along with such novels of the period as Theodore Dreiser's *Sister Carrie* and Frank Norris's *McTeague.* The similarities between the Gay Nineties and the 1980s have often been pointed out, most recently by Kevin Phillips in his article, "Reagan's America: A Capital Offense," which appeared in the *New York Times Magazine* this past June. Just as was true in the era of the Vanderbilts, Morgans and Rockefellers, wrote Phillips, the 1980s were a decade characterized by "an ostentatious celebration of wealth, the political ascendancy of the rich and a glorification of capitalism, free markets and finance."[7] Dreiser's and Norris's fictional exposes of greed find their equivalent in Tom Wolfe's *Bonfire of the Vanities,* while the real-life dramas of Michael Milken, Robert Campeau, and Donald Trump rivet our attention, first because of their legendary skills at making money, and subsequently because of their no less titanic falls from grace.

Yet trompe l'oeil money painting, especially at the hands of Harnett, Haberle and Brooks, was also a playful enterprise, wrapped up in games of illusion and riddles of identity. All three artists flirted with the theme of counterfeiting in their paintings (which may account for the Secret Service's suspicions). It is clear that the artists meant to raise issues not only of innocent deception, but also of forgery and fraud.

Harnett, for instance, was delighted when a distinguished jury of artists at the National Academy of Design accused him of submitting a work to their annual exhibition that was not an original work of art. His work was too perfect, they said, to be a painting of a ten-dollar bill; rather, he had simply pasted a real bill onto the canvas. After removing the protecting glass, the jurors tried to remove the suspect currency. To their amazement and chagrin, they found that it had indeed been painted. The title that Harnett had given the painting should have been a clue: he called it *A Bad Counterfeit*.[8]

Haberle, on the other hand, was always including little commentaries about his work within his paintings. In one of these, a work he titled *Reproduction,* he depicted a ten-dollar bill, a tintype portrait of himself, and several newspaper clippings—all rendered with such convincing illusion that the viewer is compelled to try to lift them off the surface. The clippings—which are entirely the artists fictions—openly identify Haberle as a counterfeiter, one so skilled that his paintings "would humbug Barnum."[9]

Haberle's sly reference to Barnum, his contemporary, also connects the older money painters to Boggs. P.T. Barnum was not only the circus pioneer and consummate showman that we know today, but was also renowned for the exhibits he displayed in his museums. These included such elaborate hoaxes as "genuine" South Sea mermaids and three-headed monkeys—known far and wide as Barnum's "humbugs." Despite the fact that the public knew these exhibits were suspect, people came in droves, gladly paying the cost of admission to see them. As the historian Neil Harris has noted:

> Barnum's audiences found the encounter with potential frauds exciting. It was a form of intellectual exercise, enjoyable even after the hoax had been penetrated, or at least during the period of doubt and suspicion. Barnum understood that the opportunity to debate the issue of falsity, to discover how deception had been practiced, was even more exciting than the discovery of fraud itself.[10]

For Boggs, too, it is both wholly strange and entirely fitting that people should accept his handmade bills in payment for real goods and services. The idea of participating in what appears to be a masterful deceit is seductive precisely because it falls outside of the realm of acceptable social behavior and thereby postulates a certain degree of risk.

Boggs's attitudes—towards money, towards illusion, and especially towards basic issues of trust—date back to a childhood spent growing up in the world of the traveling carnival. He was awakened at a very early age to the elaborate subterfuges and mechanisms that the various carny acts relied on for their effects, like the electromagnets that held the strongman's barbells to the stage whenever a member of the audience tried to lift them. Carny people tended to divide up the world into two distinct societies—those who were in on the game, and the rubes who made up the audience. Human gullibility was a given, but so, too, was a healthy degree of skepticism. The challenge was to overwhelm even the most hardened skeptics in a tide of showmanship.

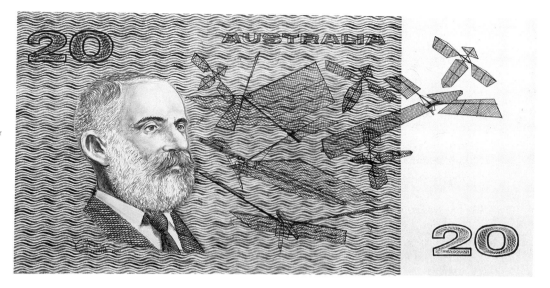

20 PAPER PLANES
1990
Ink and colored pencil on paper
25 1/4 x 50 In.

Boggs is much like Magnus Eisengrim, the magician in Robertson Davies's novel *World of Wonders*. Eisengrim spent a captive childhood with a traveling carnival, and remembered it as a time when "short weight was the essence of everything." Both Boggs and Eisengrim came away from the experience not only knowledgeable but also wary in the ways of deception.[11]

From their beginnings in the middle ages, the carnival and its younger sibling, the circus, were thought to be "invested with dishonest, unprincipled men—swindlers, counterfeiters, show men, etc.—who enrich themselves at the expense of others."[12] Eisengrim's perfectionism, his insistence that illusion should be respected as an art form rather than passed off as a complicated fraud, stood in deliberate contrast to the blowsy, down-at-the-heels tedium of his childhood. It was, in fact, intended as an antidote to that experience, scrupulous and principled even as, by its very nature, it deceived.

I have long thought that similar motives lay behind Boggs's art, that if the games of truth and deception are to be played at all, they should be played well, with full respect for their powers of enchantment and delight. Yet they also involve something much more basic. To draw the curtain aside on any of our shared illusions is to begin to unmask the paradoxes on which we build our relationships to the world.

FOOTNOTES:

1. Cited in Annie Dillard, *Pilgrim at Tinker's Creek* (New York, et. al.: (Harper & Row, 1974), p. 83.

2. Bruce W. Chambers, *Old Money: American Trompe L'oeil Images Of Currency* (New York: Berry-Hill Galleries, Inc., 1988). The exhibition dates were November 11-December 17, 1988.

3. Edward J. Nygren, "The Almighty Dollar: Money as a Theme in American Painting," *Winterthur Portfolio* 23.3, (Summer-Autumn, 1988), 129-150. Nygren's article was published immediately prior to the "Old Money" exhibition.

4. Lawrence Weschler, "Onward and Upward with the Arts: Value, I-A Fool's Questions," and "II- Category Confusion," *The New Yorker*, dated respectively January18, 1988, pp. 33-56, and January 25,1988, pp. 88-98. Reprinted together in Lawrence Weschler, *Shapinsky's Karma, Boggs's Bills, and Other True Life Tales* (San Francisco: North Point Press, 1988), pp. 178-260.

5. J.S.G. Boggs, "Art Under Arrest" *Art and Antiques*, October,1987, pp. 126-127.

6. The complicated issue of nineteenth-century monetary policy in the United States and its importance for the money painters is discussed at length in *Old Money*.

7. Kevin P. Philips, "Reagan's America: A Capital Offense" *The New York Times Magazine*, June 17,1990, pp. 26-28 ff..

8. *Old Money*, p. 20.

9. *Old Money*, pp. 25-26.

10. Neil Harris, *Humbug, The Art of P.T. Barnum* (Chicago and London: the University of Chicago Press, 1973), pp. 75, 77.

11. Robertson Davies, *World of Wonders* (Harmondsworth, England: Penguin Books, 1975) is one volume of his Deptford Trilogy, the other two being *Fifth Business* and *The Manticore*. Magnus Eisengrim is featured in all three novels.

12. This particular critique of the circus appeared in the Chillicothe, Ohio *Weekly Recorder* for August 2, 1815; it is cited in R.W.G. Vail, *Random Notes on the History of the Early American Circus*, (Barre, Mass., Barre-Gazette 1956), pp. 89-90.

DIALOGUE WITH OTIS
1988-89, Mixed media, 41 X 104 In.

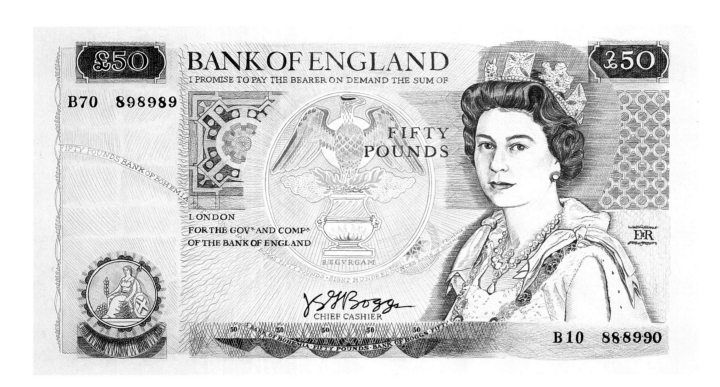

£50 NOTE # B 10 888990
1990, Ink and colored pencil on paper, 19 x 34 1/2 In.

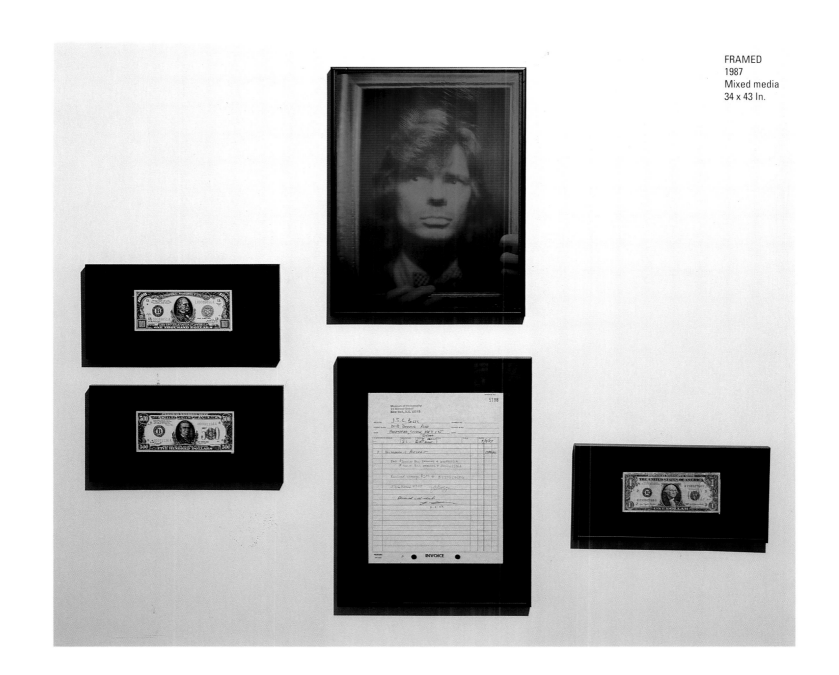

FRAMED
1987
Mixed media
34 x 43 In.

AFTER E + U
1990
Acrylic on canvas
56 x 25 In.

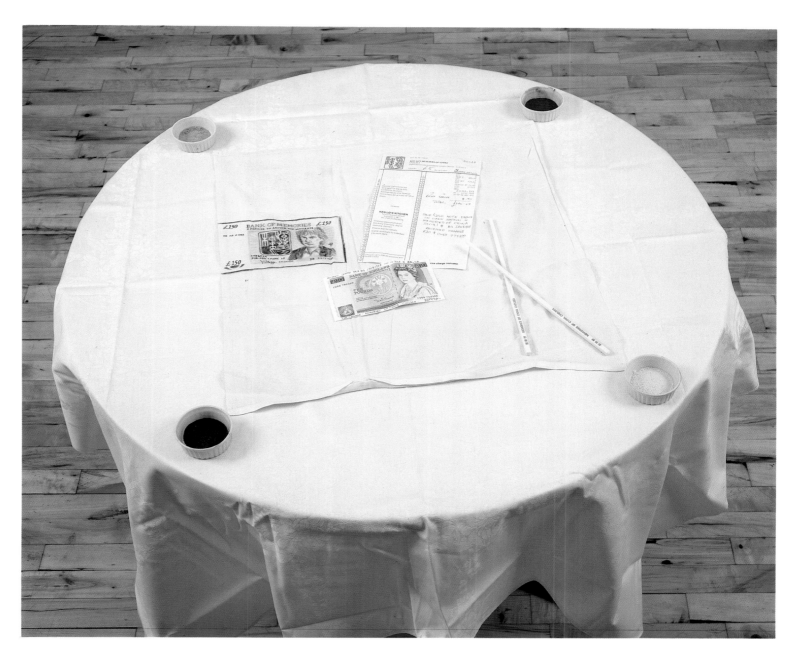

BANK OF MEMORIES - 1988, Mixed media, 36 x 36 x 31 In.

TRANSCULTURAL CURRENCY
1989, Acrylic on linen, 81 x 138 In.

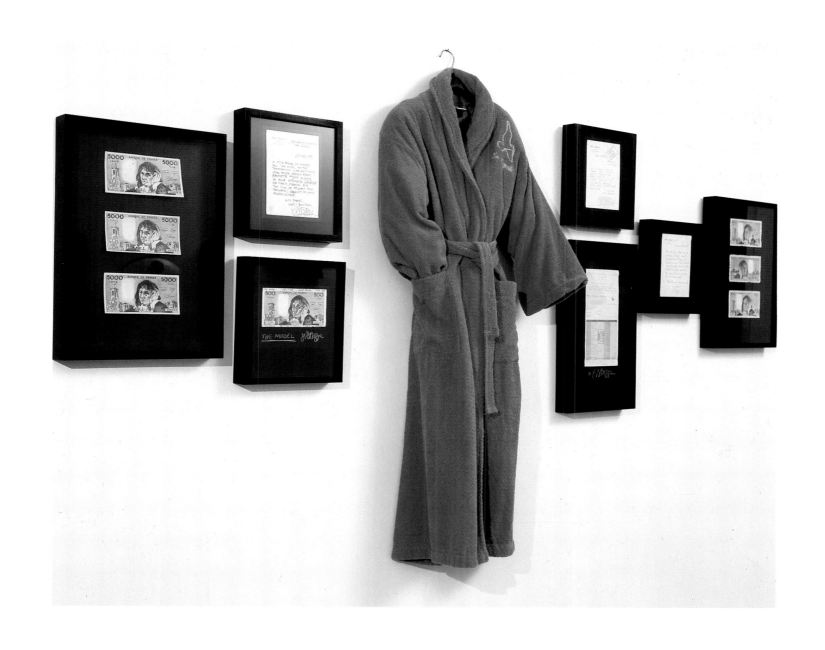

LIFE AND TIMES
1989, Mixed media, 61 x 103 In. (Approx.)

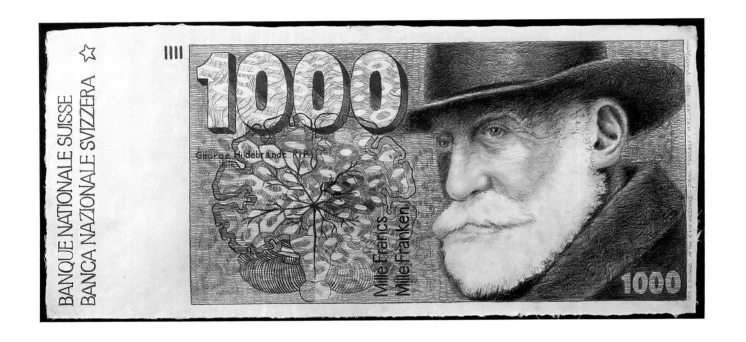

SWISS MILLE FRANCS
1989, Ink and colored pencil on handmade rice paper, 23 1/2 x 43 In.

TROMPE L'OEIL AND TRANSACTION
THE ART OF BOGGS

ARTHUR C. DANTO

Once, I acquired, for a five-dollar bill, a painting of a five-dollar bill by the American money painter, N.A. Brooks. The circumstances were these. I saw the painting, in a gold frame, displayed in the window of a junk shop on West 110th Street in New York, perhaps twenty-five years ago. Fine paintings always have a light of their own, and though, from the bus window through which I spied it, I could not make out what sort of image it was, it was immediately plain to me that it was the work of a master, violently out of place amidst the cheap furniture and tawdry bric-a-brac piled in disorder in this nondescript storefront of a marginal, sinking neighborhood. I ran back as quickly as I could, instantly perceived that it was a serious painting, and inferred that the shopkeeper had not perceived this fact, or he would have tried to sell it as such, rather than as just another item in his uninspired inventory of secondhand merchandise. I asked how much he wanted for the frame, and was told by the proprietor that I could buy it only if I gave him a five-dollar bill in place of the one he had tried unsuccessfully, to remove. The frame was mine for seven dollars more. So for the sum of twelve dollars, I came into possession of an exemplary work by a minor master of American trompe l'oeil painting. Brooks's signature was as clearly written as the bill itself was painted, though the latter was somewhat the worse for the failed history of its detachment.

The storekeeper, doubtlessly, congratulated himself on having found someone gullible, ignorant of how firmly that treasury note had been glued down. For him, I surmise, the object belonged to that genre of momentos with which small businesses preserve, for good luck, the first piece of money taken in after an opening. This is ritually withdrawn from circulation, like a sacrifice to the gods of commerce, asked to favor the prosperity of the new enterprise. It maintained the ritual that the bill should be of small denomination—no one would frame a thousand-dollar bill—but also be significant enough that framing and hanging it rather than spending it, meant, literally, that a *sacrifice* had been made, much as the ancient Greek warriors did when they burned a piece of flesh for the benefit of Zeus.

I have often wondered whether it would have pleased Brooks to know that his hand was cunning enough to fool the innocent eye of a shopkeeper who had, if no very strong conception of art, certainly a hands-on familiarity with small bills.

Endeavoring to touch is the spontaneous reflex of someone not sure of the eye's capacity to distinguish reality from illusion. My sense is that the money painters found their triumph in fooling eyes that had lost their innocence long ago, trying to get them to touch because they could not tell by sight alone whether the artist had painted a five-dollar bill, or had pasted down a real one in order to get the viewer to believe he had painted it. Everything in these wonderful paintings was calculated to enhance those doubts, a flat object flattened against a flat surface, and the viewer is obliged to decide whether the surface of the object is *in* the shallow illusory space of a painting or *on* the non-illusory surface

of a flat panel. Flatness diminishes parallax to nearly zero, eliminating recourse to the treacherous illusory device of perspective. And, maximally flat objects cast minimal shadows, and so provide weak visual cues as to whether the source of light in the painting differs at all from the source of light in the room where the painting is seen. "Trompe l'oeil is such a ritualized form," wrote Jean Baudrillard in a well-known essay: "The absence of a horizon...a certain oblique light...the absence of depth, a certain type of object (if it would be possible to establish a rigorous list of them), a certain type of material..."

We might add to this checklist the visual intricacy of legal tender, meant through its extravagant use of florid ornamentation to thwart the counterfeiter and, for that reason, to make it appear as though the painted bill *must* be real money, so that the viewer of a money painting is locked in an agony of epistemological indecision from which touch alone can release him. It is when the sophisticated viewer, looking to right and left to see if the guard can be counted on not to see him, runs his fingers over the surface to discover that that it is after all only paint, that the artist, were he present, could voice his gloating "Gotcha!" and taste the triumph of his demonic gifts. The miraculousness of my Brooks was that it even passed the touch test!

Boggs has in common with the American money painters—Harnett and Peto, Brooks and Kaye—illusionist skills, respect for the ritual dimension of money, and above all responsiveness to and respect for the elaborate faces of banknotes and greenbacks. For they are marvelous constellations of images and symbols, intricate embellishments and ornamental flourishes, signatures, numerals, letters in various styles—virtuoso setpieces of the engraver's art, visual expressions of the power of the state whose authority they emblemize. It is, on the other hand, no part of his task to fool the eye, deceive the viewer, raise vexing questions of appearance and reality, provoke doubts on the authority of the senses. Everything is, as it were, aboveboard, largely because in a great many cases it is central to his effect that he be seen drawing, and in the act of demonstrating his dazzling draughtsmanly powers. And the superlatively drawn note exists initially to precipitate a complex happening in which the "Viewer" is induced to play a role and run a risk. Boggs's is a post-modern art form, a mode of interaction between audience and artist in which each takes chances which go considerably beyond the traditional concept, central to the ideals of painting since ancient times, of cognitive error, of taking painted grapes for real fruit.

Images of money served the money painter as a kind of bait, a means of cognitive entrapment, in which his deliniative skills were matched against the viewer's visual skills in a game of right and wrong. Boggs also uses money as a form of entrapment, or at least seduction, but in a new order. He seeks to engage the Viewer as a Participant in a fascinating interchange based on the disparity, widely recognized, between the face value on a drawn piece of paper money, and the variable value of the drawing of it as a piece of art. It would be rare that the "face value" and the exchange value should be equal, as in the case of my five-dollar bill; an equality, in any case, based on someone's ignorance that the bill was art. In Indian literature, there is a standard example in which someone takes for a piece of silver what in truth was mother-of-pearl. It appeared to have a value, which dissolved in the knowledge of what it really was, proving the treachery of appearances. By rights, if someone takes for a five-dollar bill what is in reality only a few cents worth of paint, the same transformation should take place. Instead, what appears to be a real five-dollar bill is really a work of art and, as such, worth more—and perhaps a great deal more—than it would have been worth, had it merely been a piece of money. Boggs's enticed Participant knows this, which gives him an incentive to play the game. For while Boggs's money drawings are only drawings of legal tender, and as such not backed by the tresorial might of the

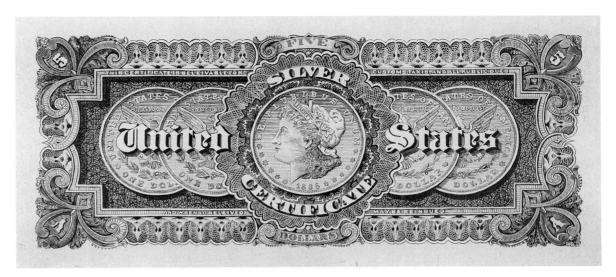

REAPPROPRIATION (A PICTURE OF A PICTURE OF A) - 1989, Acrylic on canvas, 36 x 89 In.

government, they are backed by the institutions of the art world and by the fact that there may be others prepared to exchange serious money for them.

The game is played as follows. Classically, Boggs displays himself drawing a piece of money, making it perfectly plain that deception is in no sense part of his means or aim. His aim, initially, is fascination: the Viewer is fascinated both by the way the money is drawn and by how real the drawn money looks. Were Boggs to set up a table in public and draw pieces of money, he would quickly draw a crowd. Among the onlookers, there would certainly be some who would wish to buy the drawings, ready to exchange real for simulated money, but much in the way buyers of drawings exchange real money for simulated faces or bodies, the only difference here being in the subject matter of the drawings. Boggs's drawings are not, in this sense or at this stage, for sale, however. He instead wants to "spend" the drawn money, quite *as if* it were real. No one is fooled: he is not trying to pass off counterfeit money. The truth is available to all that he made something that looks like money only to the point of *reproducing* the money's overall look: the details will differ, and Boggs enjoys improvising all sorts of joking subsitutions—signing his own name where that of the Secretary of the Treasury officially belongs, writing "Measury" for "Treasury," and the like. The point is to transform Viewer into Participant by getting him to treat the drawn money as if it *were* what it is only *of*, and giving over goods in exchange for it, at the accepted market value of the goods, just as if this was a perfectly ordinary transaction. Since the price is always lower than the face value of the bill, Boggs expects real change.

Once the transaction is achieved and Boggs is in legal possession of the goods or service for which his "money" was exchanged, the money is transformed into a work of art, and the Participant into Owner. The game does not end here, however, as it does with most sales of art. Of course, the Owner could play the same game with some new party as Boggs had played with him: he could endeavor to "spend" it, as Boggs had. But as it is art, it may now be worth a great deal more than it could be "spent" for, since the rules of spending require that whatever is purchased have a fixed price. But

the drawing's value as art is indeterminate. And the Owner must now make a delicate decision: to keep and enjoy the work, or to endeavor to sell it and realize a profit—or to keep it and enjoy it with one eye while the other is on the art market. Will works by Boggs become more and more valuable, or less and less? When is the right time to sell, if you are going to sell? Either way, there is a lot to enjoy in the drawing, including being able to tell the story of the transaction itself through which one came into ownership of it. I enjoy my five-dollar bill, but I also enjoy telling the story of how it came to be mine. I also know that works by N.A. Brooks are going up in value, and I may someday decide that it is time to sell. The public is now more aware of the art market, and is more conscious of the potential increase or decrease in the value of any work of art. Boggs counts on that consciousness, thereby keeping the Viewer-Participant-Owner engaged.

In a way, Boggs's work is less the drawing than the transaction the drawing facilitates. After all, it is a drawing of a piece of money, and in truth the transaction could take place, as in some cases it has, if instead of drawings these were laser-reproduced facsimilies of real currency. Still, the actuality of their being drawings plays a certain role in the transaction, mainly because of the quality of the drawing and the pleasure the Owner takes in the artist's evident and palpable skill. If, indeed, the Owner keeps the drawing, one would think Boggs would be fulfilled as an artist, but in fact this is not altogether true of a *transactional* artist. If the Owner keeps the drawing, Boggs will have earned only what he has been able to spend the money for, and considering the amount of energy, the amount of sheer nerve that it required to bring off such a transaction, the risks Boggs runs of being mistaken for something other than he is, the reward—at least the momentary reward—is not great. His real income as an artist will depend upon whether the Owner perceives the drawing not as a drawing, but as the key part of the transaction, and at this point additional components come into play. These are the pieces of change or ephemera which Boggs has documented in some way as belonging specifically to this transaction: the bill of sale, the cancelled ticket—together, wherever possible, with the goods, or documentation of the services, for which the money was originally spent. The transaction includes these components. And Owner and Boggs will each have part of the work—the Owner the drawing, Boggs the rest—each in consequence a hostage to one another. Either of them can sell his part of the transaction to a third party, who can then engage in new negotiations to bring the transaction into another completion.

The piece of money, however brought into being, is the nucleus around which a number of objects orbit in a constantly changing series of transformations, bids and bets, calculated risks, in which individuals and objects play different roles, take on different metaphysical identities, face losses of money and philosophical status. It is a kind of happening. The happening climaxes when the drawing, in becoming art, confers the status of art on a number of things not ordinarily thought to enjoy that exalted position, and not perceived as art save against a knowledge of the narrative of the transaction and of its rules. It is a kind of magic. The components enter the world of art together as a "Boggs," something to be collected, reproduced in catalogues, interpreted, and enjoyed in the way works of art are. It has become a privileged, transfigured object. And the game can go on and on!

To understand the transaction is to appreciate the transfigurative power of the institutions of the art world, which intervene at appropriate moments. It is also to grasp a narrative of dangers and metamorphoses. At the heart of the narrative, of course, is Boggs as a kind of seducer, a tempter, a provocateur, a conjurer, initiating the transaction through which there is the chance, as in some sort of financial deal, for everyone to prosper. Boggs must be appreciated, then, within the realm of the performance artist, and a word must be said about this remarkable genre of art-making. It is here that the artist places himself or herself at the boundary between art and life, and in doing so, courts genuine peril

THAT KRAZY KOOL AIRE, CANON LASER COPY COLD CASH CURRENCY
1989
Mixed media
78 x 54 x 18 In. (Approx.)

in the distant hope that some powerful transformation may occur. The performance takes place on two levels: it is art and real life at once. The drawings themselves are art and money—art that looks like money which becomes money if trusted as such and can, like real money, be cashed in for real goods. It exposes Boggs to real risks just because the government holds a monopoly on the issuance of currency, and Boggs, in getting the Viewer to participate in the transaction by accepting the drawing as money, immediately criminalizes the action.

Performance artists characteristically expose themselves to comparable dangers of being injured or attacked. Their art emerged at a moment when artists were, in various ways, protesting the institutional character of the art world, and sought to colonize the real world in the name of art. I have often thought of the performance artist as a kind of priest, prepared to sacrifice himself or herself in order to restore to art its edge of danger, and to collapse the barrier between reality and art, which protects the two from leaking into one another. In *The Birth of Tragedy*, Nietzsche describes the frightening excesses to which an ancient community became susceptible when it undertook what began only as a dramatic performance. The actor might, just might, at the climactic moment, be possessed by a god, at which point the chorus will be transformed into celebrants, the barriers between chorus and and audience become obliterated, and the entire community gets caught up in the sort of orgiastic sacrifice one reads about in *The Bacchae*. When the barriers between men and gods are breached, the barriers between art and life are swamped, and something horrifying and liberating at once takes place—something so powerful that the dangers are worth courting. It is possible to argue that the dark memory of this power and danger accompanied the ancient Athenians when they attended dramatic festivals, and that what Aristotle speaks of as catharsis is a reenactment of ancient transfigurations.

Nothing secular has an aura more seductive than money, which, when one thinks about it, yields a qualified metaphor for man. Human beings are supposed to possess a certain value, just by virtue of being human, whatever they do with their lives, however morally soiled they may become. A five-dollar bill is worth five dollars, however torn and crumpled, worn and frayed. I have often thought the old money painters chose conspicuously used bills for their models in order to mount a kind of religious allegory. Those bills of humble denomination retain their worth, however many hands they may have passed through, whatever indignities they may have suffered. It cannot be an accident that we use the word "redeem" in connection with souls and money. The worn and torn have as great a value as the new and crisp. Bills of great denomination enter too marginally into circulation to yield these moving parallels. If the religious analogy were protracted, the bills of high denomination would be like saints, as outside life as it is possible while still being within life. The bills of low denomination are taken for granted, since nothing is more commonplace than money, and it is inevitable that a celebrator of the commonplace, like Warhol, should have painted dollar bills—and, more peculiarly, two-dollar bills. Boggs's interest in money is the polar opposite to that of Warhol. He is interested in money for its visual beauty—something of which we are rarely aware as we count bills or stuff them into wallets—and part of his output consists of works which magnify, hence glorify, money as beautiful, as if the outward intricacies of design and symbolism were emblematic of money's inner worth. Indeed, if we paused to look closely and carefully we would see that, as an engraving, a mere dollar bill should be worth far more than its face value (I once read of a man who advertised steel engravings of George Washington for twenty-five dollars, and sent dollar bills to those who answered the ad). Boggs makes magnifications of different currencies so the Viewer can see, without benefit of a jeweler's loupe, what ordinarily cannot be seen with the naked eye. Of course he takes great liberties with these magnifications as well: he showed me a large ten-dollar bill on which he intended to place a picture of the Supreme Court Building in place of the United States Treasury. And he takes pleasure in making sly and impudent alterations. Easily overlooked, so that,

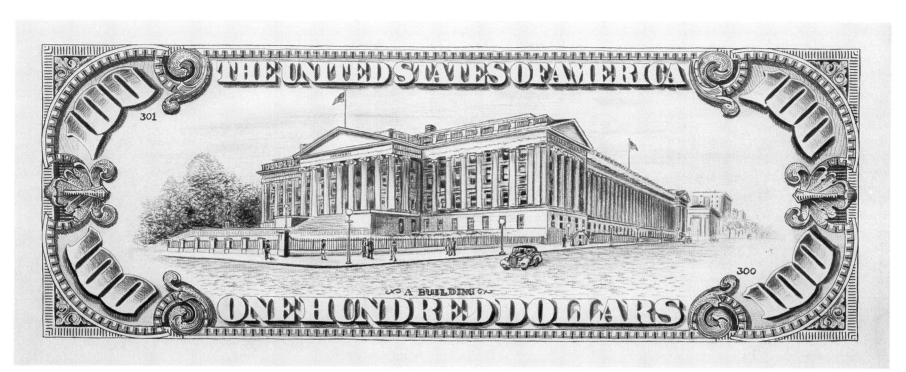

in a sense, the shadow of illusion falls across the faces of these large paintings, but at a different point than that of the money painters. No one thinks a very large bill is a real bill, but it is easy to believe that Boggs's big bills are but enlargements of small ones. And Boggs's punning wit plays across these handsome surfaces, laying traps for unthinking eyes.

Once, under instructive circumstances, I acquired a work by Boggs; not a drawing of a dollar bill but a modification of one. I was at the opening of a show of his at the Vrej Baghoomian Gallery. We were to meet afterward, and someone gave me an address. I had no paper to put it down on, but the surroundings prompted me to fish a dollar bill out of my billfold to write down the information. When Boggs, from across the room, saw this act, after all an hommage to his own vision, his eyes gleamed. Like the character in *The Madwoman of Chaillot* who, when asked whether a hundred-franc note belonged to him, replies that *all* hundred-franc notes are his, all money is Boggs's province. He took the bill from my hand and began writing. He wrote his own name over the signature of the Treasurer, and he crossed out the serial number, putting in one of his own. And then he dedicated the work to my wife, Barbara, and me by writing at the top, "For A & B." I intend to frame it, and hang it just below my five-dollar bill by N.A. Brooks. The space between them will be a metaphor for the philosophical distances which unite and separate two ways of turning money into art.

LIST OF WORKS - (Chronological Order)

Page 18 SWISS MILLE FRANCS
 1989
 Ink and colored pencil on handmade rice paper
 23 1/2 x 43 In. (Framed)

Page 15 20 PAPER PLANES
 1990
 Ink and colored pencil on paper
 25 1/4 x 50 In.

Page 18 £ 50 NOTE # B 10 888990
 1990
 Ink and colored pencil on paper
 19 x 34 1/2 In.

Page 20 AFTER E + U
 1990
 Acrylic on canvas
 56 x 25 In.

Back Cover FOUNDATIONS OF AMERICAN VALUES
 1990
 Acrylic on canvas
 67 x 147 In.

Page 10 K NOTE # B 29051990 B
 1990
 Ink and colored pencil on Basingwerk paper
 4 1/2 x 10 3/8 In.

Page 11 TOWARDS A BRICK
 1990
 Mixed media
 2 5/8 x 6 1/8 x 1/2 In.

NOTES: Some works listed may not be exhibited at all venues
 Ownership of individual works not listed by request of the artist

BIOGRAPHY — Born Woodbury, New Jersey, 1955.

EDUCATION:
 Columbia University, New York City
 Camden Arts Center, London, England
 Hillsborough Community College, Tampa, Florida
 Miami University, Middletown, Ohio
 Sinclair Community College, Dayton, Ohio
 Brandon High School, Brandon, Florida

ONE MAN EXHIBITIONS:
1991 "smart money (HARD CURRENCY)" — Carnegie Mellon University Art Gallery, Pittsburgh, Pennsylvania
 Grand Rapids Art Museum, Grand Rapids, Michigan
 Smith College Museum of Art, Northampton, Massachutsetts
 Laramie County Community College Museum of Art, Cheyenne, Wyoming
1990 "smart money (HARD CURRENCY)" — Tampa Museum of Art, Tampa, Florida
1989 "Paintings, Drawings & Transactions" — Vrej Baghoomian Gallery, New York City, New York
 "Money and Numbers" — Galerie Demenga, Basel, Switzerland
1988 "Money" — Galerie Demenga, Basel, Switzerland
 "J.S.G. Boggs" — ART: 19:88, Basel, Switzerland
 "Legal Tender" — Fort Apache, London, England
1987 "More Money" — Young Unknowns Gallery, London, England
 "Money" — Jeffrey Neale Gallery, New York City, New York
 "J.S.G. Boggs" — Art LA:87, Los Angeles, California
1986 "Art is Wealth - Drawings" — Midland Bank, Hampstead, London, England
1985 "Large Numbers" — Gallery 3RE, New York City, New York
1984 "Numbers" — Artshow, London, England
 "In Dependence" — Sokol Hall, New York City, New York
 "Stephen Boggs" — 1st International Contemporary Art Fair, Barbican Center, London, England

PUBLIC WORKS, PERFORMANCES
1989 "The Underworld" — Performance series, Sydney, Australia
 (I. "Drawing Down Under")
 (II. "Holiday in Hell")
1988 "A Year Without Money" — Worldwide
 "The Mayor's Underwear" — Chicago, Illinois
1987 "The Trial" — Courtroom #1, The Old Bailey, London, England
 "Making Money: It's So Simple" — Randolph Street Gallery, Chicago, Illinois
 "The Truth About..." — Randolph Street Gallery, Chicago, Illinois
 "To Live and Die in L.A., Shopping on Rodeo Drive" — Los Angeles, California
 "Who is J.S.G. Boggs" — Art Institute of Chicago, Chicago, Illinois
1986 "Arrested" — Young Unknowns Gallery, London, England
 "Drawing Around" — Performance in 12 parts, Worldwide
 "Another Day, Another Dollar" — New York City, New York
 "Leery of Lira" — Milan, Italy
 "Rooftop Painting" — East 71st Street, New York City, New York
 "The Rate of Exchange" — Art 17:86, Basel, Switzerland